Attunement

Mandala Coloring Book

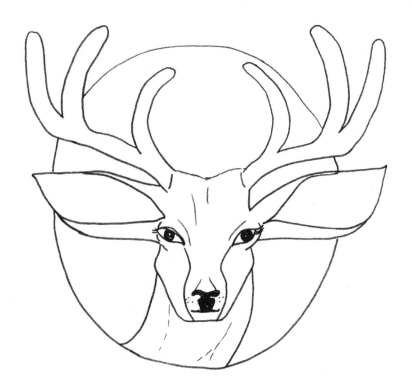

REBECCA BLOOM, ATR-BC, LMHC

First edition

Cover image by Rebecca Bloom, Inked by Rachel Lordkenaga

Cover design by Rebecca Bloom

Back cover photo by Stacy Honda

Illustrations by Rebecca Bloom

Book design by Kat Marriner

Library of Congress Cataloging-in-Publication Data

Bloom, Rebecca

Attunement: Mandala Coloring Book

In loving memory of Peggy Nast-Hayes

Therapist, Friend, Mentor

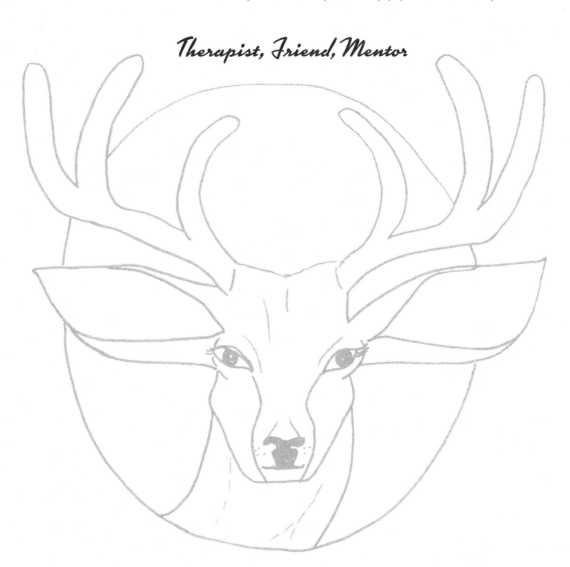

Contents

Introduction

A FUNNY THING happened between the publications of my first book of art therapy exercises and this book. The whole world suddenly discovered what I had seen throughout my almost two decades in the art therapy field: adults like to do coloring pages. Research even says it is as effective as silent meditation to calm and focus the brain. It's been amazing to receive images from all over the world, my favorite being racks of coloring pages from one of Costa Rica's airports. I've also had people stopping me in meetings to tell me how much coloring helps their clients, family, and friends. The American Art Therapy Association even issued a press release saying coloring sheets are excellent for self-care.

So why now? Why this sudden explosion in coloring sheets? One, I think the world has become so connected to screens that many people are looking for ways to fill time with the screens turned off. Coloring books offer an accessible, portable way to tune out the world and tune inward. This coincides with the buzzword in Psychotherapy today— Mindfulness. How to tune into internal signals and allow them to be, without judgment, is now a skill many therapists hope to teach during the counseling session. One of the pioneers of bringing this focus to the field of counseling is Marsha Linehan. In her pioneering Dialectical Behavior Therapy (DBT), she describes how to increase distress tolerance, the ability to tolerate feelings, and coping skills. Coloring offers support of just this kind. In those times when it's hardest to be with ourselves or others, what can we do to calm ourselves? Many have found that the structure of coloring sheets allows for this to happen. We may need to shut out the world to feel calm.

It's managing the mental games that matters most. That is what I hear from people under stress. Too often we know we have the technical skills to complete a project, but somehow the stress gets to us and we just don't get the results we want. Mandalas and mindfulness offer people the ability to handle stress and mental clutter, to give it order and containment, so they can get a sense of clarity. Suddenly, we are not spinning lots and lots of plates or feeling like we are running in circles unsure of what to do next. After we take time to look inward, when we look back up again, we see just one plate, one path, the one that's important to attend to right now. We gain a sense that we can master the "to do" list.

Taking time to color offers a time to collect one's thoughts. To my clients, I describe it as, "After you have made pudding by mixing the ingredients together, you have to put the pudding in the fridge, it has to set, and it takes a while to reformulate into something more solid." For some people, it's the creation of art itself that quiets the mind and gives folks a chance to change their mental state, for things to gel. The coloring brings calmness.

This also speaks to why this book is called *Attunement*. I spent three years taking classes with Dr. Janina Fisher , a therapist who focuses on trauma treatment. Her work looks at what connects us, and repels us, from others and ourselves. It was through this work that I began to understand attunement at a new level. When we feel at peace and in relation, we have attunement. A very famous image of attunement is a loving caretaker holding a newborn, looking into its eyes while the baby gazes back. The wholeness that happens in that moment literally calms not just the mind, but also the whole nervous system. When we make art, we can find that moment on our own. Creation offers Attunement.

There are a couple of ways this book is different from the last one. Most importantly, I transitioned from having others make the images to hand-drawing three-quarters of the mandalas myself. This was not the plan

because I have always viewed myself as a good enough sketch artist, but not someone who could draw realistically. When it became clear that I was going to be making the images, I had to dig very deep, practice what I tell my clients and turn off my inner critic, be a beginner, and draw. And draw and draw and draw. Many drafts, many reworks followed. I purchased countless "Draw Animals, Step by Step" books and found that I could do a pretty good job of it. A "Good Enough" job, as I tell my clients.

Finding the time to draw was also an issue. I drew at workshops, at my son's musical performances, on the couch with the television on. There were also all the times I planned to draw but did not. The supplies went with me many places but did not get used every time. The process was a great reminder of how many factors have to be in place in order to make art.

Some of these images reflect the time and place they were made, imbued with energy I could have never imaged at the time. The most touching

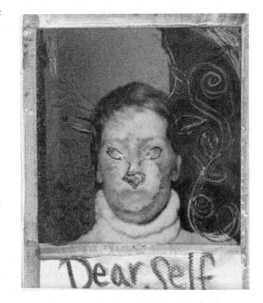

for me is the cover image of the deer. The idea of just the deer face came from a Polaroid self-portrait I made years ago. In the original selfie, you take the Polaroid, hold it at arms length, and lens facing you and click. Then the wonderful whooshing noise happens as the grey image is released from the bottom of the camera. As the image is appearing before your eyes, you have about three minutes to mess with the emulsion; a pencil works great for this. In my self-portrait, I had drawn antlers on myself. I called the image "Dear Self," a pun on "deer self."

I had made several sketches of what the deer mandala could be for this coloring book, but the day it popped off the page I was sitting next to my friend and fellow therapist, Peggy Nast-Hayes. Peggy had the type of energy I always want to be close to. Steady, with a warm smile and wicked sense of humor. That day of the workshop, she said she did not want to walk very far on our break, that her leg had been bothering her. A few months later, I learned that Peggy had brain cancer, and only a few months after that, she passed away. When I look at the deer mandala, I see her. I knew it had to be the cover.

Social media had a big influence on this book as well. I made a closed critic group on Facebook. There I posted images in progress and title ideas, and went to the group when I needed help to keep going. When it came time to create the cover, I thought it would be fun to engage social media again for a coloring contest. This would allow the cover to reflect how I hope the book will be used. At a memorial service for Peggy, a friend of hers mentioned that she frequently wore polka dots. Peggy's adventurous dressing was always an inspiration to me. It was my hope that I would get submissions back from the coloring contest that incorporated polka dots. To my delight, several did. It is a great pleasure to have the cover coloring artist be Rachel LordKenaga, who in 2005 was an art therapy student in the first class I taught in the Antioch Art Therapy Masters program. She's a wonderful therapist and painter. It is a delightful gift to have her version of the deer on the cover.

There are four sections to the book: animals alone, animals in relation, abstract shapes in relation, and a selection of the mandalas I have been making on my own for years. And again with the mandalas!?! Why put everything in relation to a circle? Because mandalas are about connectedness, the form relating to itself. Because I've seen in my work that the form is the most soothing to people. In America, most people are familiar with the sacred geometry form of Mandalas, where the images are symmetrical and balanced. I follow the Joan Kellogg theory

of mandala making. In her view, there are many other ways to make an image in a circle. They may be unbalanced or exploding out of the circle and such images are equally important to more traditional mandalas. Indeed, I find that the most interesting things happen when we are just a little off balance.

What to do if you are coloring and you get stuck?

- Spin your coloring sheet—color upside down, on its side.

- Allow it to be "perfectly imperfect" as Marsha Linehan states in her DBT work.

- Look at it from a distance. As with Fractals, pull back far enough and you will find order. Also, everything looks better at a distance.

- Imagine how your favorite artist would color and make that image.

- Put your favorite music on and just go for it.

- Fill the page with words instead of color.

- Only color outside the circle.

- Carry the image with you all day and only add to it when you feel like it.

- Begin at the bottom of the image and work up.

- Begin on the sides and work in.

- Begin at the middle and work out.

- Only use scissors.

- Act the fool.

- Consult your horoscope and then make the image.

- Imagine it is the last image you will ever make.

- Imagine it is the last image you will ever see.

- Color with your mouth, elbows, or toes.

- Follow your bliss.

- Use only one color.

- Use three shades of the same color.

- Use only primary colors—blue, red, yellow.

- Use only secondary colors—purple, green, orange.

- Use two colors opposite on the color wheel—blue and orange; red and green; yellow and purple.

- Use only earth tones: browns, greens, and blues.

- Use only pastel colors.

- Use only colors you cannot stand.

- Use magazine images and make it a collage.

- Use glitter glue pens, and give it a long time to dry. Or don't; when it's still wet, put another piece of paper on top and then remove it for a "ghost print."

- Use leaves and other natural items in your image.

- Try coloring on the out breath and then on the in breath.

- Ask your inner critic to leave the room, and then make art.

- Make copies of family photos and incorporate them into the image.

- Know that none of this makes sense and just make art anyway.

- Trust and begin.

- Distrust and begin.

Animals Alone Mandalas

I LOVE THE idea of power animals. With my clients, I use them to help folks reframe their issues. By seeing how another being interacts with the world and solves problems, we can see our problems in a new light. We can then come at our issues with a new clarity. I use two decks of animal cards in my office: Steven D. Farmer, Ph.D.'s *Power Animal Oracle Cards* and Philip and Stephanie Carr-Gomm's *The Druid Animal Oracle*. Both sets have over 40 cards. But what is fascinating is that some cards get picked way more often than others—the possum, the otter, the dog, and a few others. It seems there are some animals that reach our psyches more than others. As I began to think about how to narrow it down, to make my own images, I reached out.

I posed the question to friends, what's your power animal? All of the single animals you will see next are from their answers. It was interesting how much easier it was to draw an animal for a certain person. A chicken for Dana—the image full of how she told me that one special one in her coop pranced around, so proud of itself. A raven for Kay—it was several drafts till it had enough wisdom and power. Those first drafts looking more dinosaurian than avian.

The one that is most special to me graces the cover. As noted previously, I drew several drafts of it while sitting next to my friend Peggy. Months later I learned she had cancer and a few months later, she passed away. The day I drew the deer was the last time I saw her. It feels like it holds her gentle force.

Before you get started with each image, take a moment to think about what association you have with that animal, and how you feel when you look at the image. Now it's time to color.

Chicken

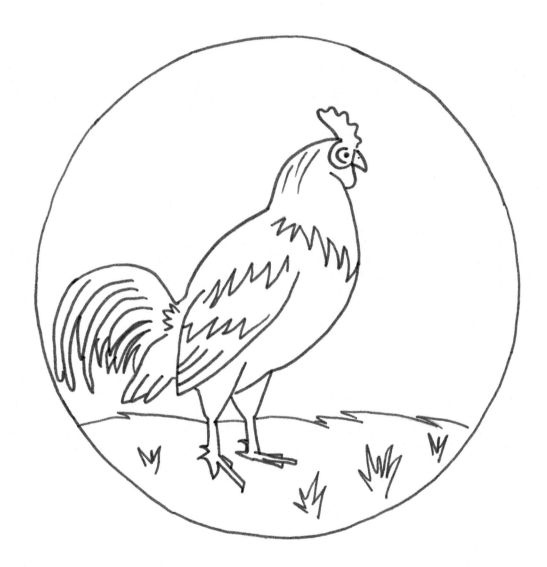

Monkey

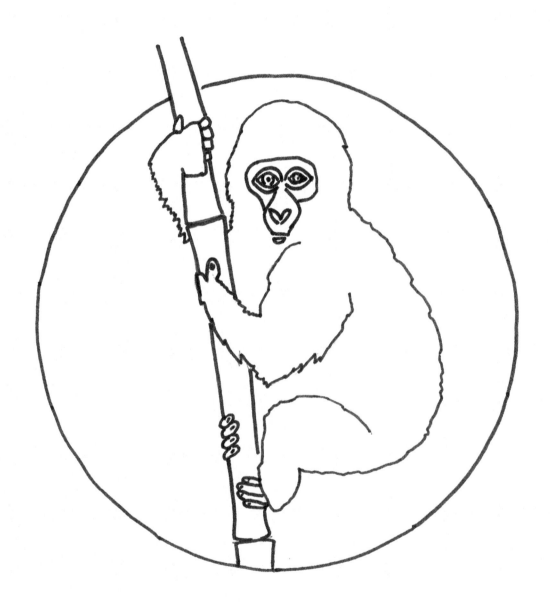

Dragonfly

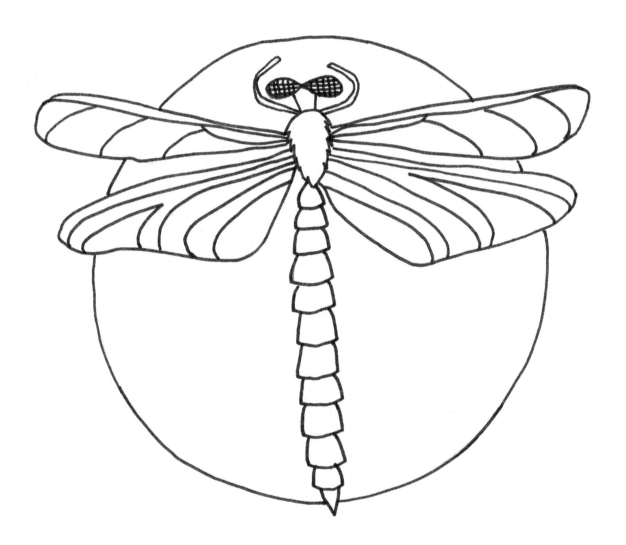

Deer

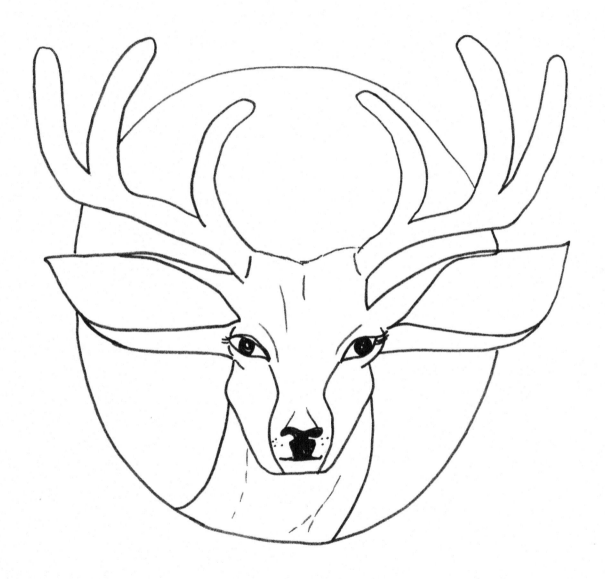

Octopus

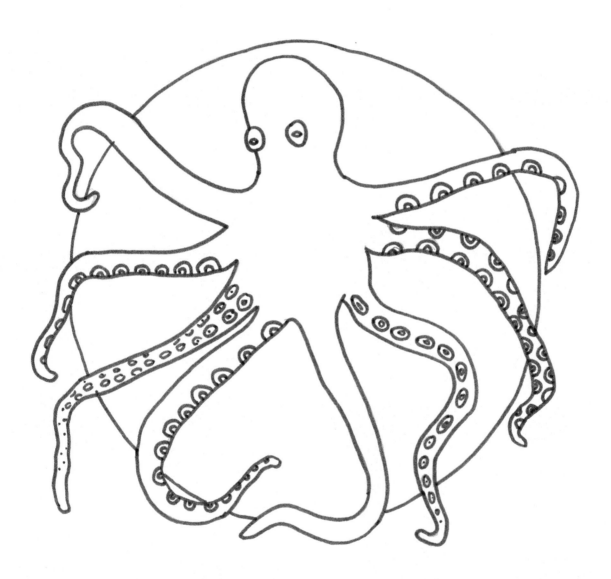

Raven

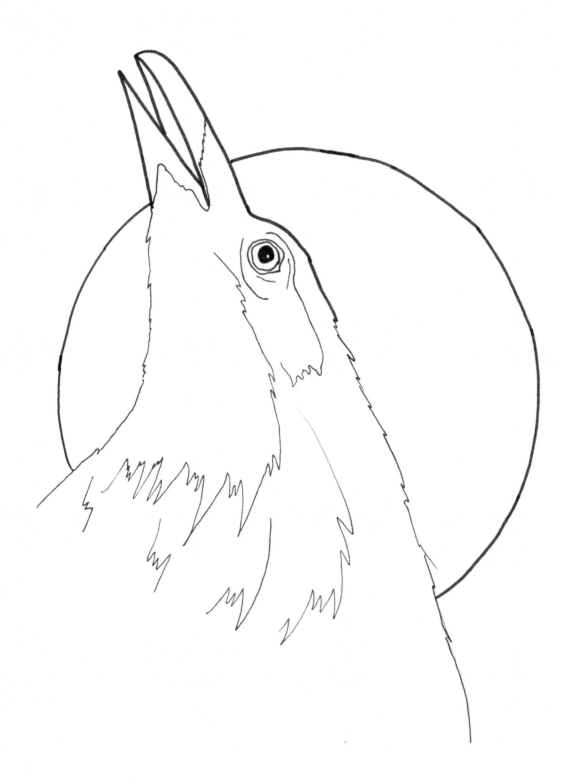

Swan

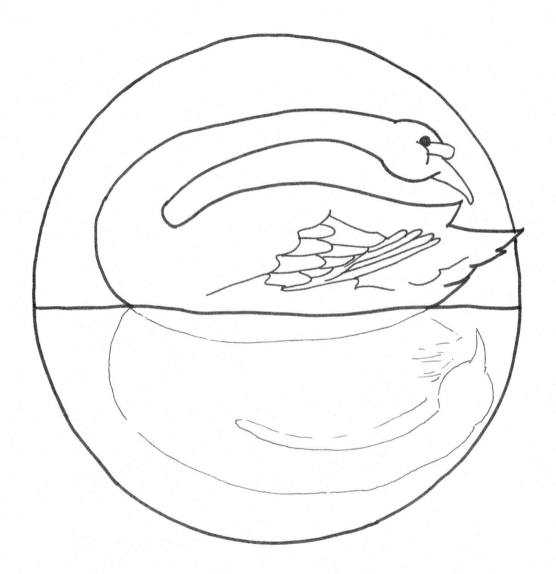

Big Cat

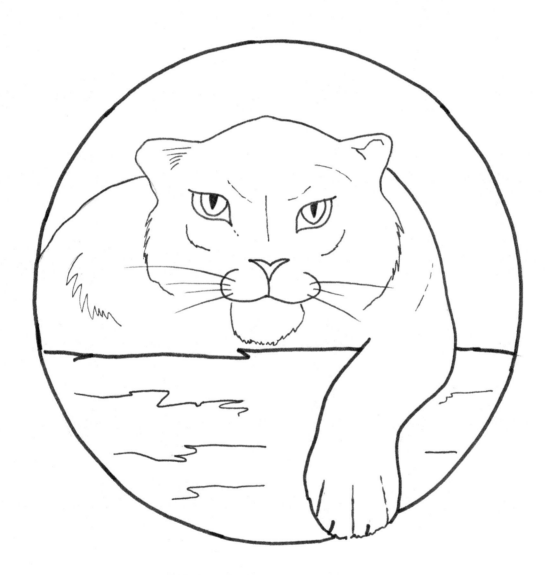

Frog

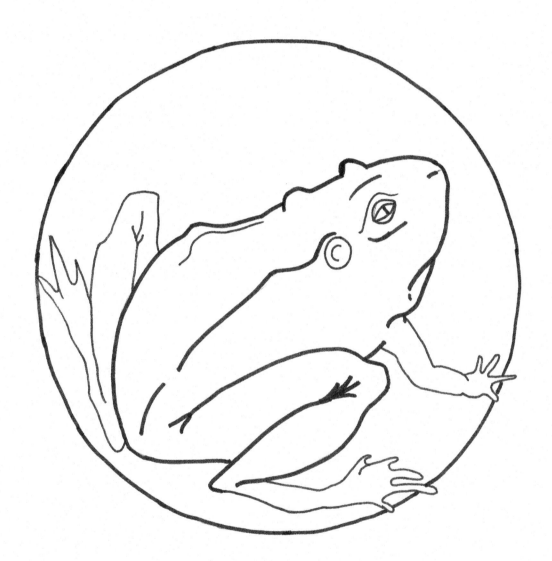

Snake

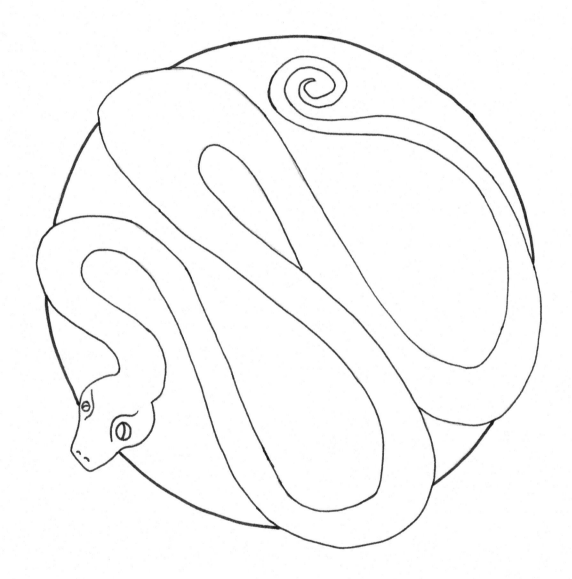

Animals in Relation Mandalas

HOW DO ELEPHANTS parent? How do otters sleep? How are beavers such good parents?

When I asked my friends and colleagues what animals had the most impact on their clients, I got a surprising answer—baby animals. I thought about that and realized it went back to attunement. We want safe ways to look at and explore the truth that we need connection and care, that we need to be seen and witnessed. When viewing images of baby animals and those that show baby animals being cared for and watched over by their parents, we get that moment to focus and put ourselves in that baby animal's place. The Japanese Hello Kitty line is based on this idea—cuteness that inspires empathy. We can feel that nurturance, even if in reality, we may have not gotten it as children. Feeling it now, a sense of closeness, creates a new memory track, which allows the brain a new place to go when we get in a downward spiral. It can work as a new place for the brain to land. "Wait, I know what it feels like to be cared for" can replace, "I'll never be cared for."

When preparing to color these images ask yourself, "What do I see in their relationship?" and think about what associations you have with this pairing.

Elephants

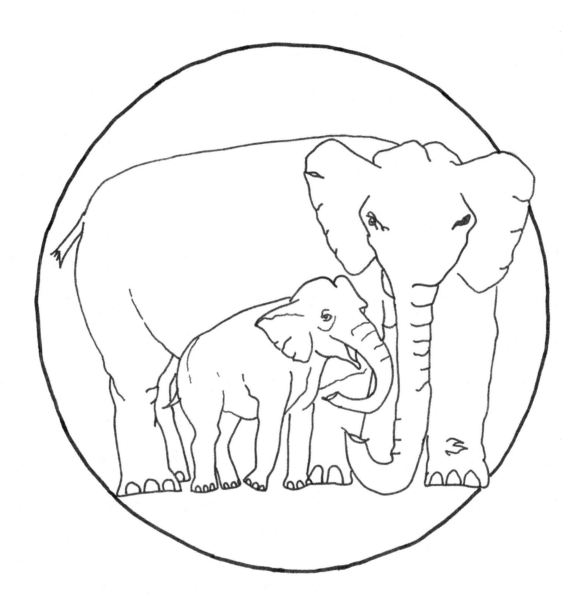

Otters

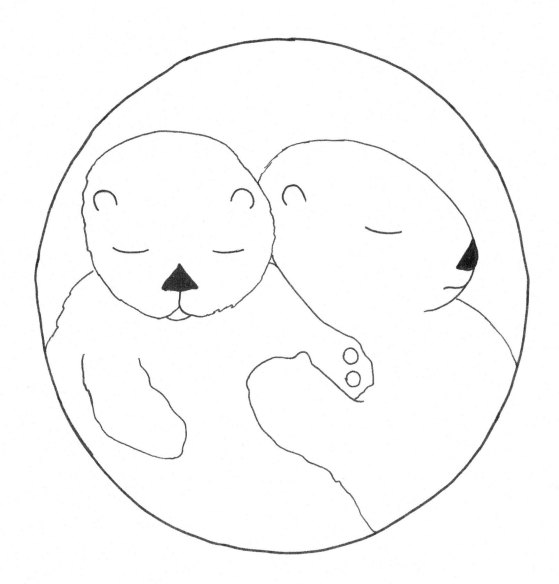

Tortoise and Hare

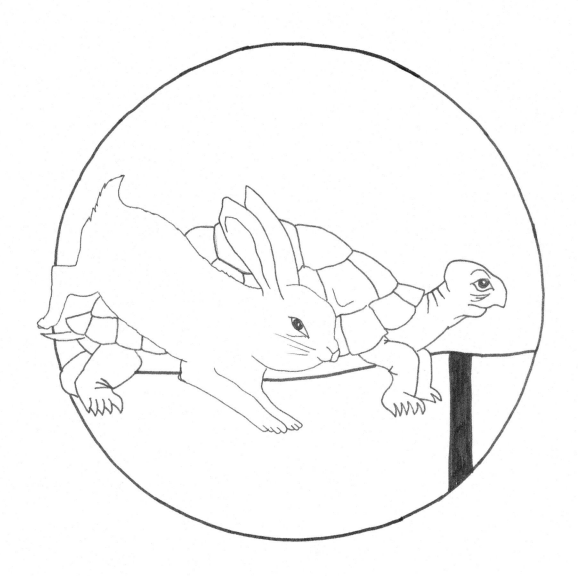

Seahorse Family

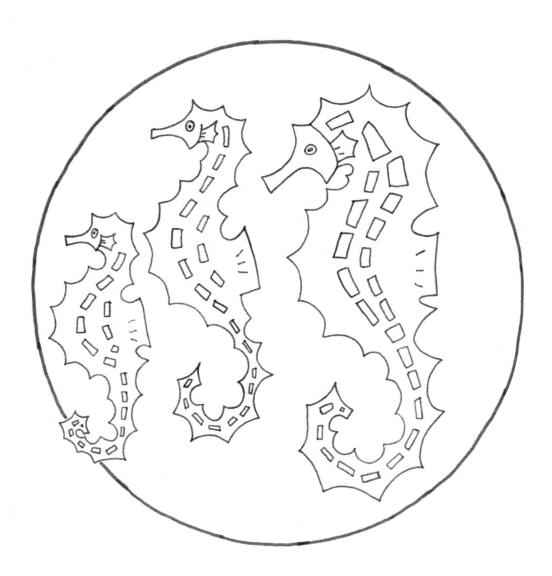

Sloths

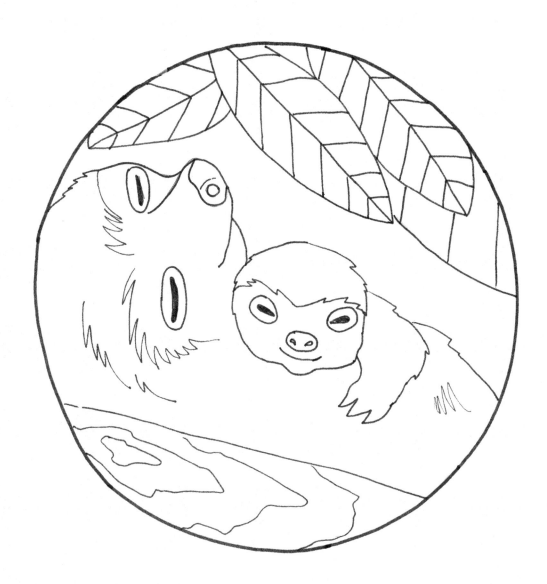

Eagle and Serpent

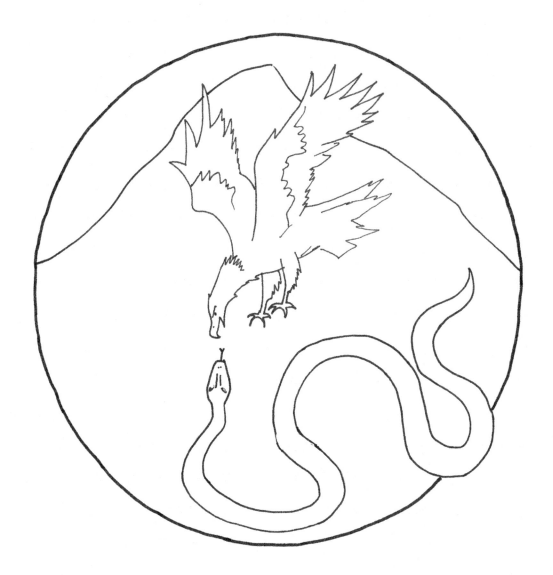

Giraffes

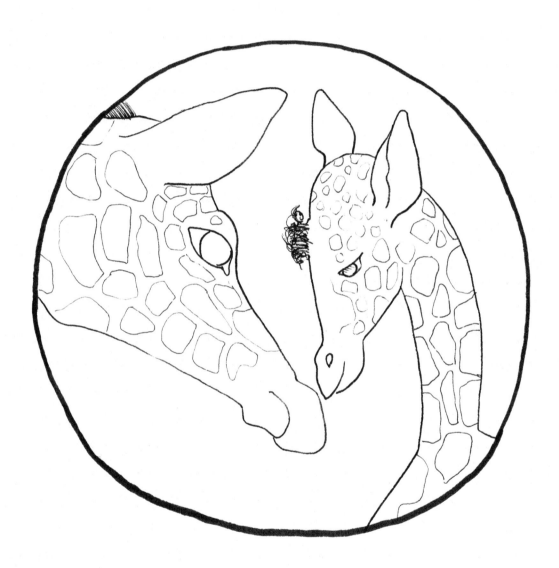

Bears

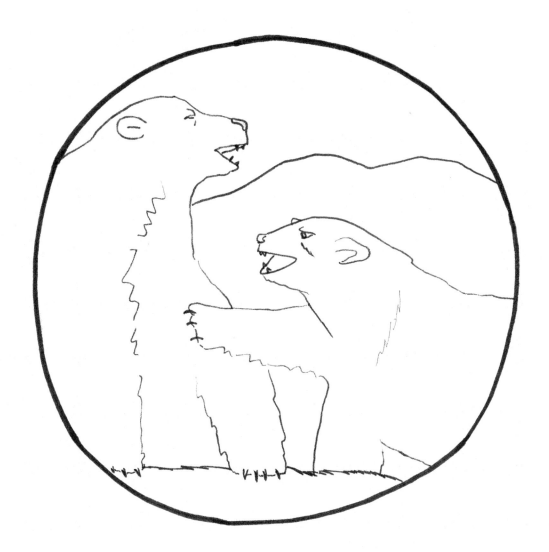

Penguins

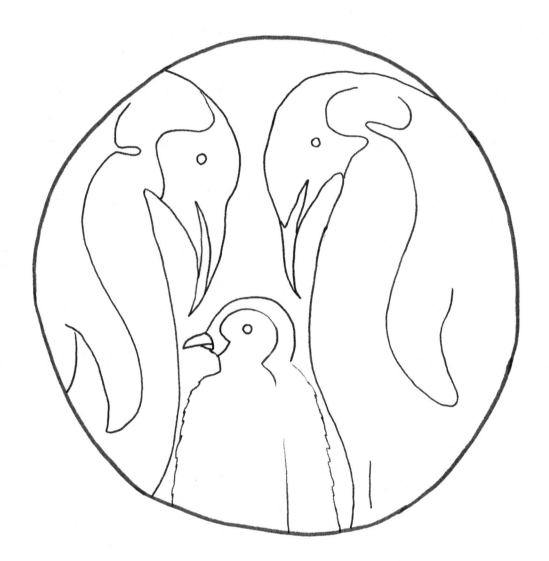

Wolf Pack

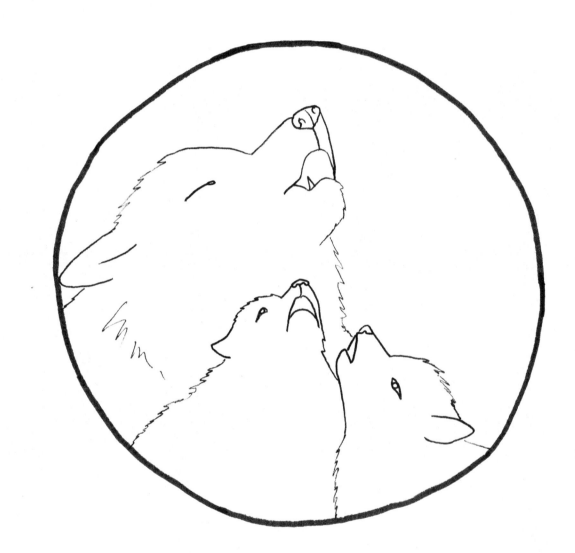

Beaver Den

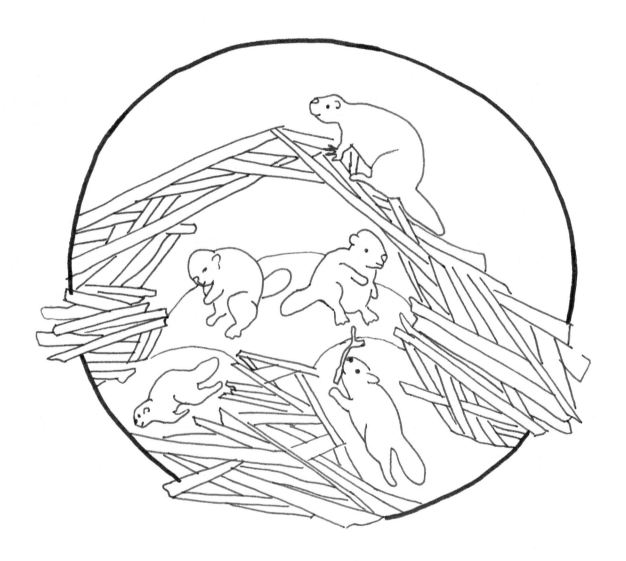

Abstract Shapes in Relation Mandalas

AS WE STRIP away known forms, we can explore the relationship between shapes anew.

Many of the coloring mandalas you see now are very busy, with a pie shaped wedge of intricate design being repeated over and over again. Joan Kellogg, who created a projective test where participants drew mandalas and selected cards of different colors and designs, would view these images as reflecting society at its most organized pinnacle. Like a church stained-glass window, a mosaic at a mosque, or a Tibetan sand painting, these highly complex images show great skill and order.

But sometimes we need a prompt, with space to fill with our own imagery, and that's what this series allows. There is room between the shapes to leave empty, or explore what is missing, or what could connect them. I am thinking of what happens to me when I watch a Butoh. This form of experimental dance came out of Japan after the horrors of World War II. Tatsumi Hijikata and his partner Kazuo Ohno performed often painted completely white, with minimal costumes, in complete silence. The movements were slow and methodic and expressed the pain and intensity of living and the beauty—the tremendous, unmistakable beauty of growth and change. The first time I saw Butoh, I was in awe. It gave so much space for me to think, deeply, about my own life.

And so, too, these coloring pages offer a simple space to reflect and explore, to see a little on the page and make it your own.

Take a few minutes to note and write down:

- If you experience connection or tension between the forms.

- What colors or textures would bring them closer together?

- What colors and textures would bring them further apart?

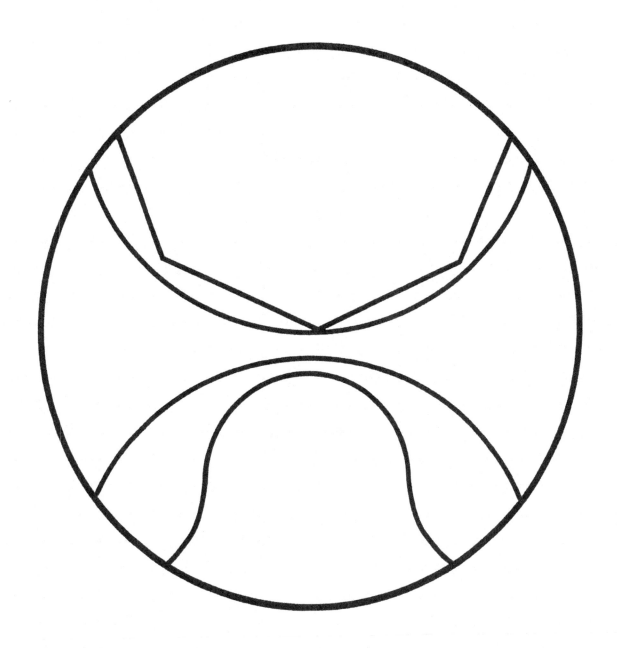

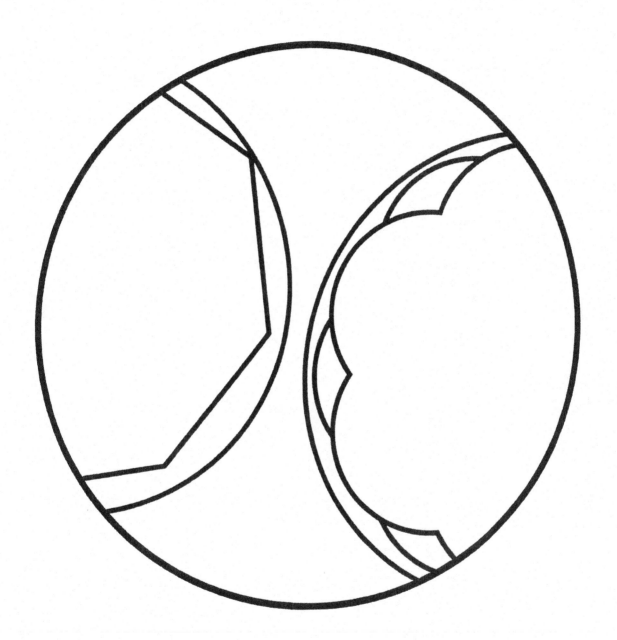

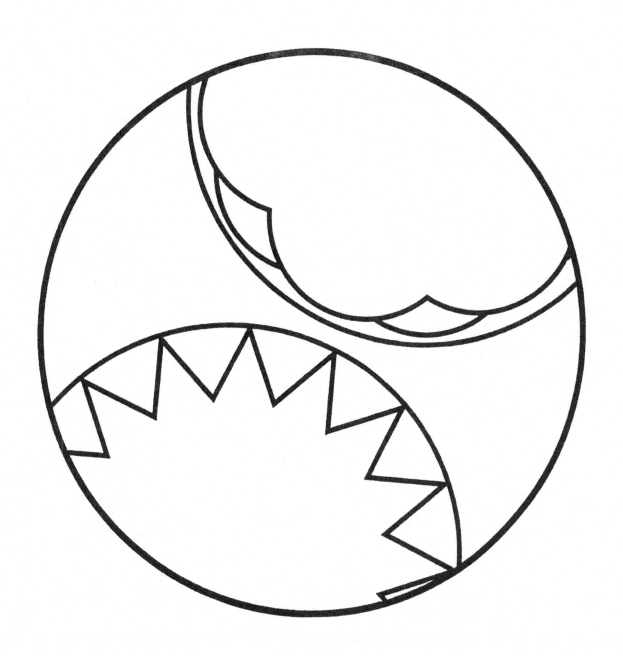

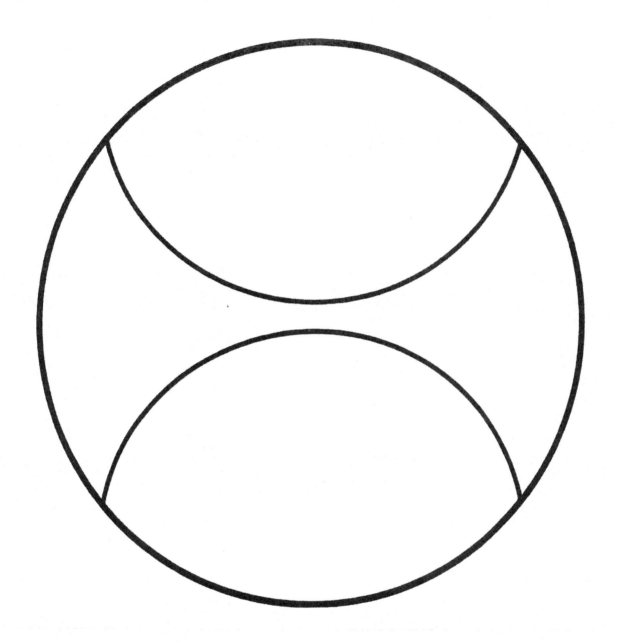

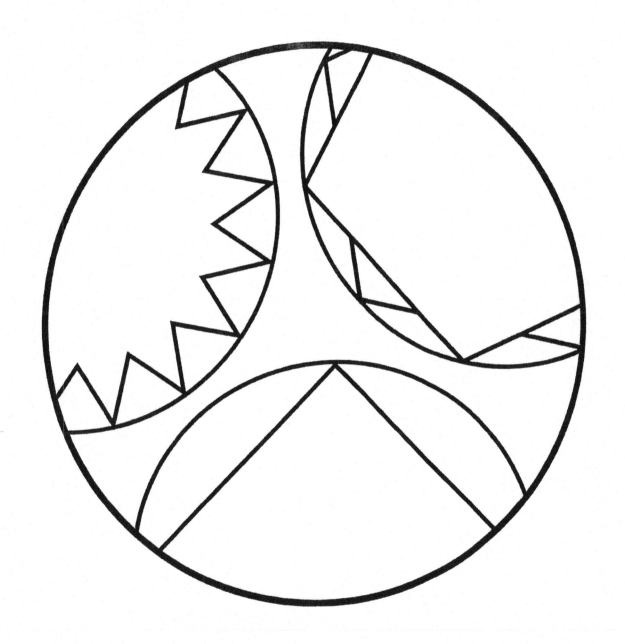

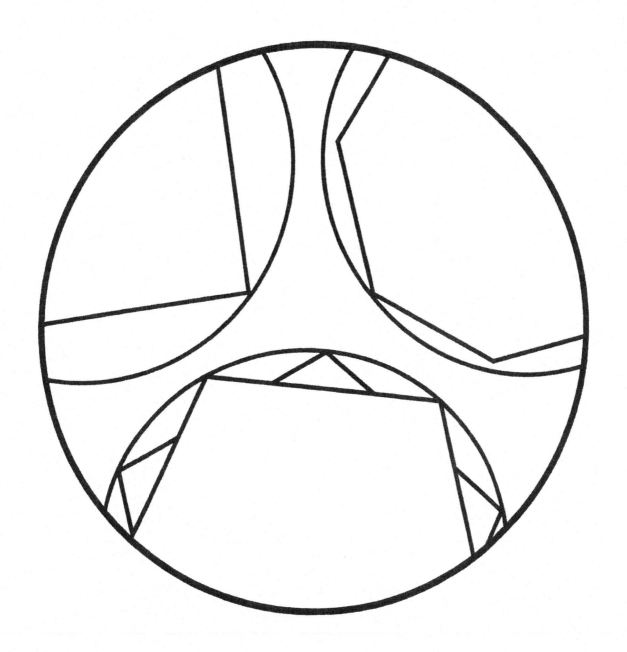

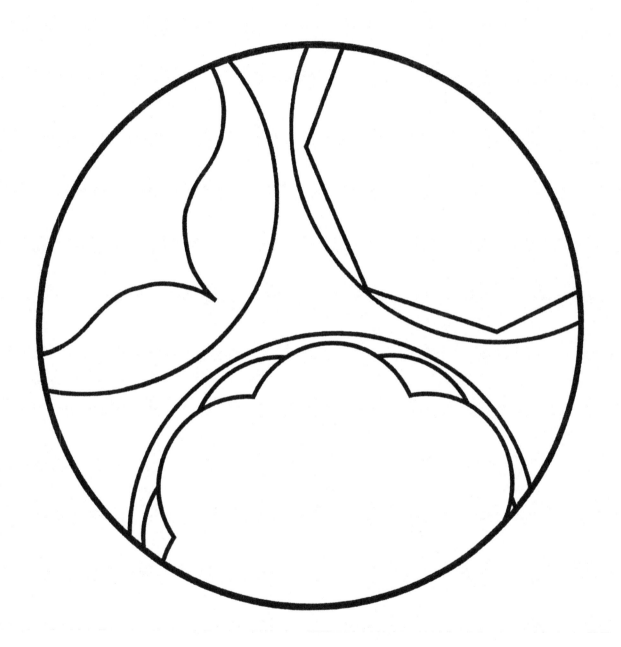

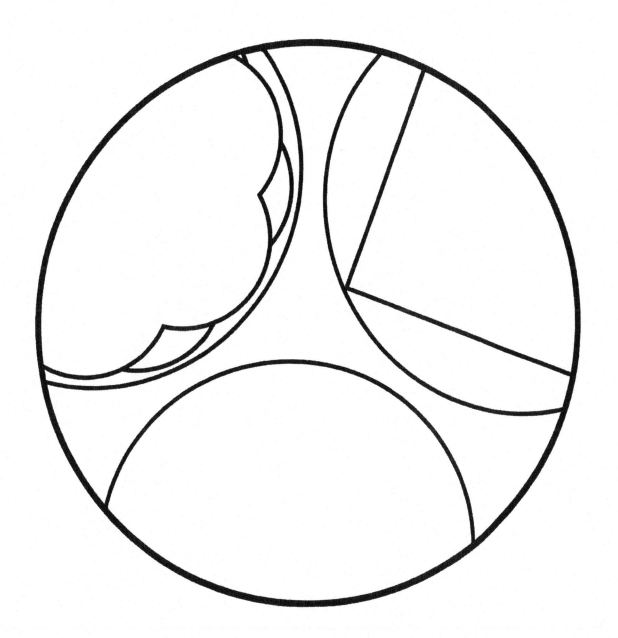

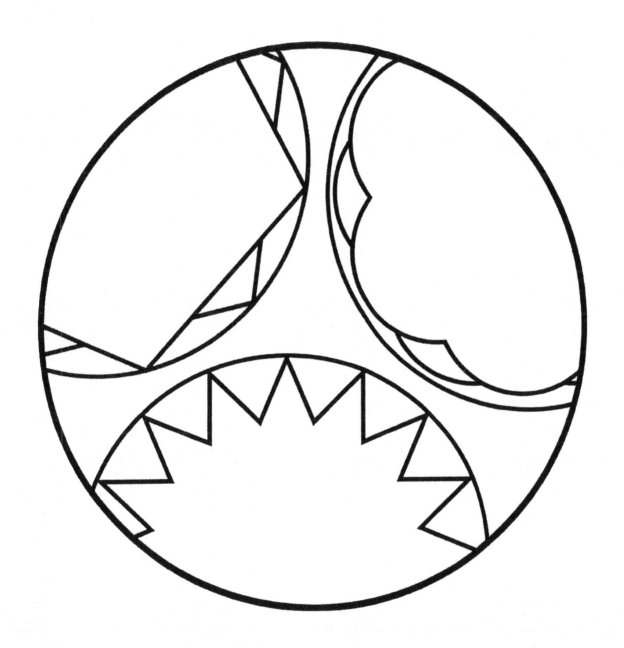

My Mandalas

WHEN I HAVE time, this is what I draw. I take a piece of paper and draw a circle in the middle, three or four passes. It's imperfect, often lopsided. I like the little wedge shapes that are left on the sides of the overlapping circles. They are good for coloring in. I then begin to fill in the circle, first with large shapes (often ellipses), and then I begin to fill in those new shapes that are created. What follows shows how the images can be symmetrical, asymmetrical, in the frame or out of the frame, structured or free form, shaded hard or soft.

These mandalas offer an opportunity to explore a multiplicity of shapes in relation. No two people will make the same image. You get to choose what you want to make. It allows you to be in the moment and be with your inner voice right now.

Now, go make art!

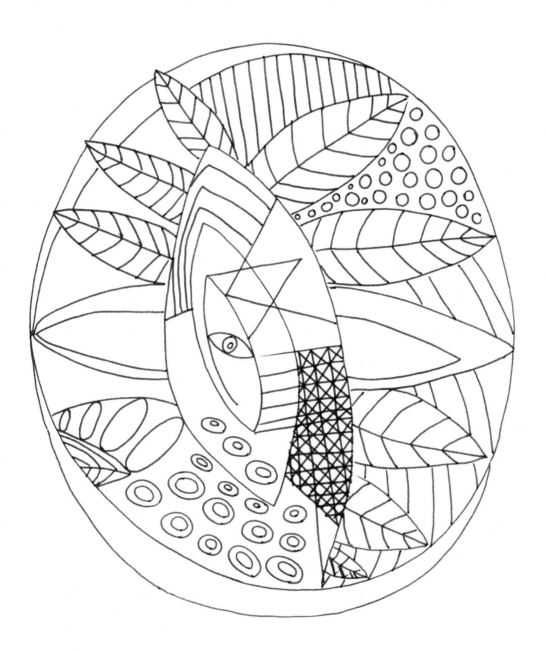

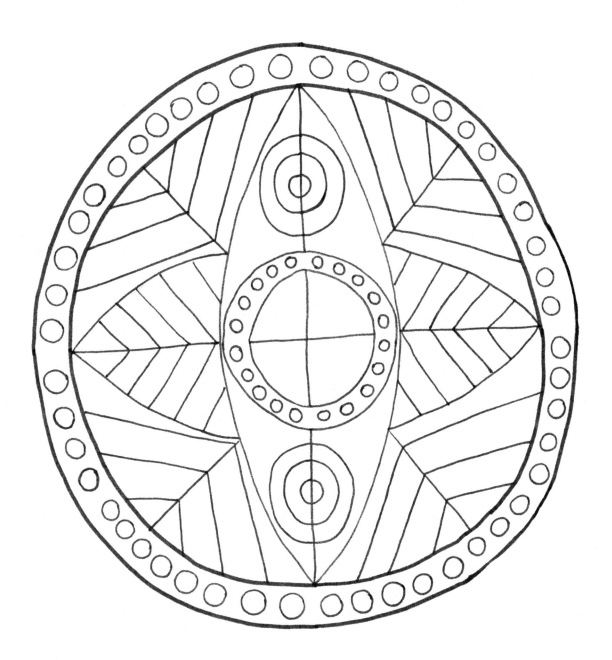

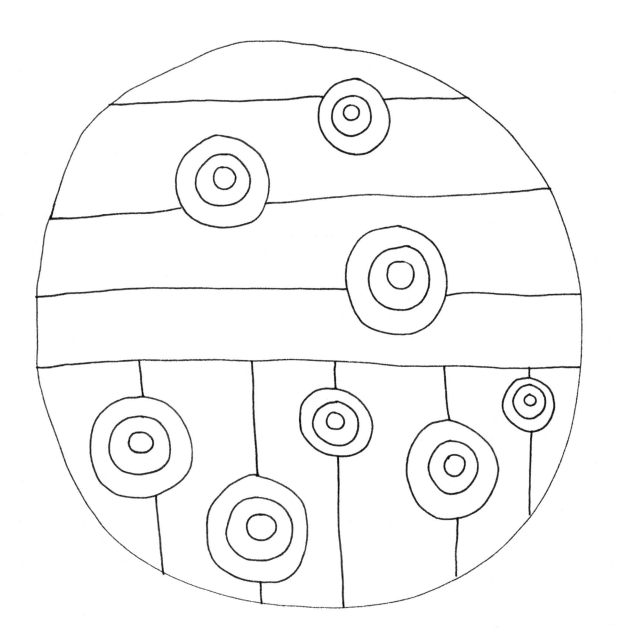

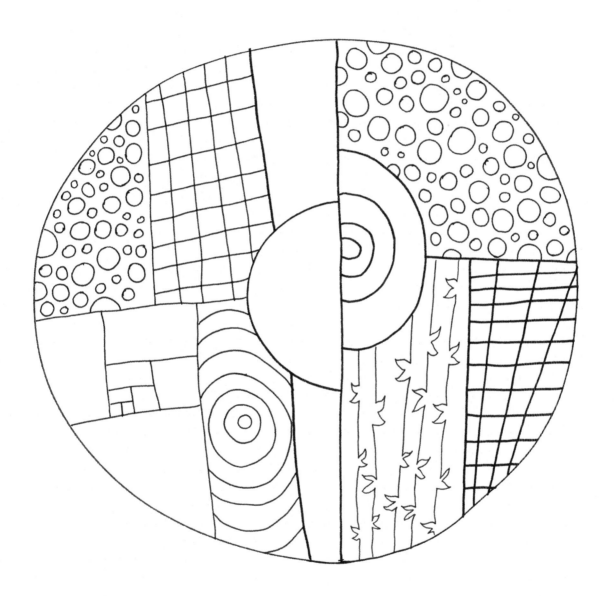

Acknowledgements

DURING THE PRODUCTION of this book, I learned that I have a type of mononucleosis that flares from time to time. I had always said about myself that my most productive hours were between 10 a.m. and 2 p.m., and that in that time I could get a whole lot done. I now know why my life runs in these little bursts. It was my fantasy to have fifty original images in this book, but as the mono flared and flared again, I realized that what I had was enough. There is so much of me in these images, most of them hand drawn, and there is so much of what I've seen people connect to over the years. My hope is that there is at least one image in this book that you connect with. That you see yourself, or an aspect of a struggle you experience, or a connection you hope to feel more often.

I'd like to thank my friends and family for their support. I squeezed in making this book between everything else that happens as a working parent. Thanks to everyone who bought the last book and sent me your thoughts. That book sold at least one copy a week on Amazon for two and a half years. Being a self-published author, my success with the last book all happened through word of mouth and the Amazon "other people who bought this also bought that" algorithm. It was a nice run.

I am thankful to have so many people in my life who keep making art. They inspire me to keep producing and exploring. I keep going because I keep creating.

Image Source Material

All images drawn by Rebecca Bloom. Some inspired by …

Deer – *Drawing Animals Made Amazingly Easy* by Christopher Hart. Watson-Goptill: 2006, page 84-85

Chicken – *Draw 50 Animals: The Step-by-Step Way to Draw Elephants, tigers, Dogs, Fish, Birds and Many More* by Lee J. Ames. Watson-Gustily: 2012

Monkey – www.pinterest.com/pin/462533824207536941

Dragonfly – *Draw 50 Animals* by Ames

Raven – expose-photo.de, copyright Alexander van Reiswitzs

Snake – AusBatPerson on Flickr, www.pinterest.com/pin/462533824206798959

Big Cat – used with permission: Jason Brown Photography, *Irina on the Prowl*

Frog – *Draw 50 Animals* by Ames

Elephants – *Draw 50 Animals* by Ames

Otters – Zibbet.com, "Cute Otters Holding Hands" by WhenGuineaPigsFly

Rabbit and Tortoise – *Draw 50 Animals* by Ames

Seahorse – *Draw Ocean Animals* by Doug Dubosque. Peel Productions: 1994.

Eagle and Snake – *Draw 50 Animals* by Ames

Beavers – www.pinterest.com/pin/462533824207589559/

Polar Bears – Paul Nicklen's Polar Bears

Giraffes – www.pinterest.com/pin/462533824207536961/

Wolves – www.pinterest.com/pin/462533824207536979/

Penguins – www.pinterest.com/pin/462533824207602708/

Sloths – feedly.com

Shape in Relation Mandalas – Conceived by Rebecca Bloom, designed by Laura Carothers

REBECCA BLOOM is a Licensed Mental Health Counselor and a Board Certified Art Therapist living in Seattle with her family and nine-pound rescue chihuahua. She has a private practice where she sees mostly adult clients who are addressing Anxiety, Depression, and Trauma. She presents often on Art Therapy for Anxiety and Depression, Art Therapy for Trauma, and the impact of Vicarious Trauma on Clinicians. She podcasts regularly at *Psychology in Seattle*. She enjoys making hand-made felt from wool roving and making it into hats, scarves, and wall hangings and then giving it away to friends and family or actions for causes she believes in.

Follow Rebecca Bloom at any of these places:

www.bloomcounseling.com

www.facebook.com/squarethecircleworkbook

twitter: rbloomatr

instagram: rtext

A list of art therapy ideas is ever growing at:

www.pinterest.com/rebeccabloomsea/art-therapy/

CPSIA information can be obtained
at www.ICGtesting.com
Printed in the USA
FSOW04n2005070617
34757FS

9 781945 178139